A HISTORY OF

France

THROUGH ART

Jillian Powell

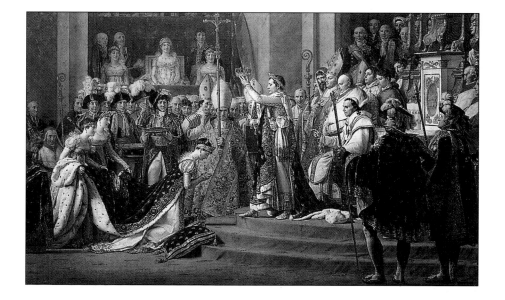

Wayland

Titles in this series

A History of Britain through Art

A History of France through Art

A History of Italy through Art

A History of the United States of America through Art

Cover: *The Storming of the Bastille* by Jean Dubois
Title page: Detail from *Coronation of Napoleon by Pope Pius VII* by Jacques Louis David

Series Editor: Rosemary Ashley
Book Editor: Joanne Jessop
Designer: Jean Wheeler

First published in 1995 by Wayland (Publishers) Limited
61 Western Road, Hove, East Sussex, BN3 1JD, England

British Library Cataloguing in Publication Data
.Powell, Jillian
History of France Through Art. –
(History Through Art series)
I. Title II. Series
944

ISBN 0-7502-1556-9

Typeset by Jean Wheeler
Printed and bound by L.E.G.O. S.p.A.,Vicenza, Italy

Acknowlegements
The Publishers would like to thank the following for allowing their pictures to be reproduced in this book:
AKG London 6, 11, 17, 18, 23, 27, 33, 35, 39; The Bridgeman Art Library cover, title page (Giraudon), 4, 8 (Lauros-Giraudon),
12–13, 15, 19, 21, 22 (Lauros-Giraudon), 24 (Giraudon), 25 (Giraudon), 29, 31 (Giraudon), 32 (Giraudon), 37 (Giraudon), 38;
Michael Holford 5; © Imperial War Museum 41, 43; Life File 9 (Emma Lee); © DACS, London 1995
Fernand Léger *The Builders*, Musée National Fernand Léger 45.

CONTENTS

The pictures in this book span thousands of years of French history – from the first settlers of the area to the present day. The works of the different artists have been chosen to portray some of the major events and experiences that have shaped the history of France.

EARLIEST PEOPLES

People have lived in the area we call France for a very long time. Scientists have discovered miniature carved figures and tools and cave paintings that were made about 30,000 to 10,000 years ago.

Some of the world's most famous cave paintings are found in caves at Lascaux in the Dordogne, in south-west France. The Lascaux cave paintings are more than 20,000 years old. The artists covered walls and ceilings with pictures of wild animals such as bison, horses and mammoths (elephant-type animals that no longer exist). The 'Hall of Bulls' at Lascaux is 21 m long and most of the animals are painted much larger than life-size. The artists made paints from earth and sand mixed with animal fat, and they used their fingers, leather pads or brushes to apply the colours.

Cave paintings at Lascaux
The artist used charcoal made from burnt wood or bones to paint these cattle on the cave walls.

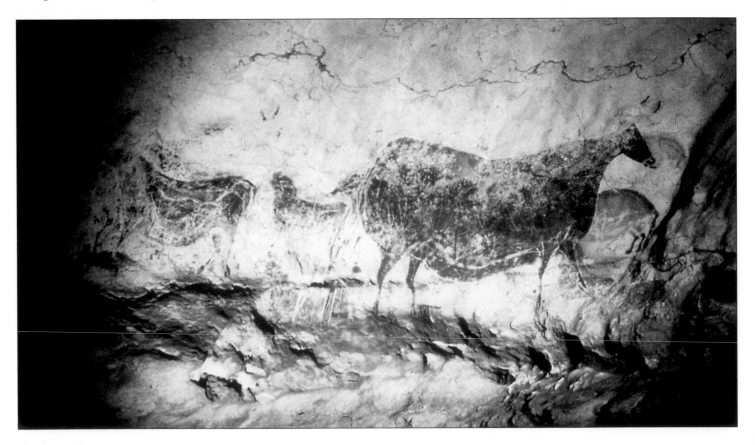

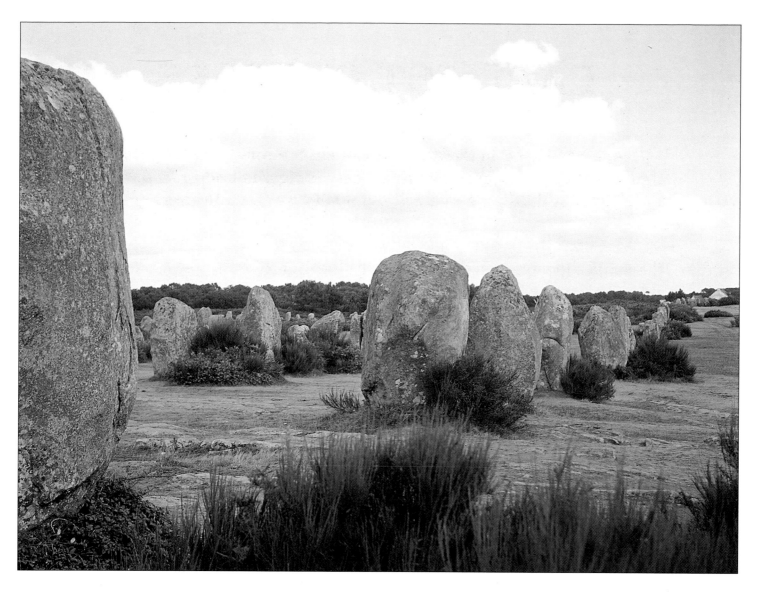

The people of the time may have believed that these cave pictures carried special magical powers that would help them in their hunt for animals, which provided them with food and clothing.

The standing stones, called menhirs, at Carnac in Brittany, date from about 2500 BC. The tallest stones are between 3 and 4 m high. Some of these giant stones were placed in parallel lines and may have been used during religious festivals. Perhaps the people walked in ceremonial processions through the avenues formed by the giant stones. Single stones may have been placed in an upright position as tombstones for important people. These stones are still standing today.

Standing stones at Carnac, Brittany

At Carnac in Brittany, thousands of menhirs, or giant stones, are arranged in lines running from east to west and ending in a semi-circle. They seem to have been carefully placed according to the position of sunrise and sunset on the summer solstice (longest day of the year).

THE CELTS

About 3,000 years ago, the Celtic peoples began to move down from the snowy foothills of the Alps into the lands of northern and eastern Europe. Their settlements extended from Ireland in the west to the Balkans in the east. They were skilled warriors, farmers and craftspeople. The ancient Greeks called these people *Keltoi* (Celts), and the Romans called them *Galli* (Gauls). The Roman word gave France its first name: Gaul.

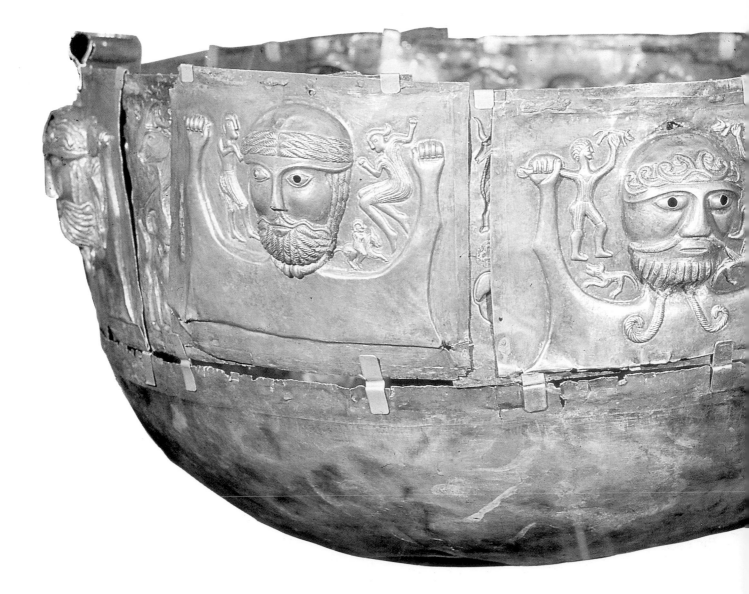

The people shown on this silver bowl, or cauldron, are Celts. The cauldron was found in the nineteenth century in Gunderstrup in Jutland, Denmark, and was probably made in the first century BC as an offering to Celtic gods. It is decorated inside with figures of Celtic horsemen and foot soldiers. It also shows trumpeters and a scene of a human sacrifice to the gods. The outer panels show faces that may represent gods and goddesses.

The Celts settled where they found iron, which they used to make axes, swords, daggers, knives and chariot wheels. They also made many beautiful objects, like this silver cauldron, and silver and gold jewellery such as neck rings, bracelets and armlets. Bowls, cups and drinking vessels were made for holding wine. Early Greek writers describe the Celts as handsome, blond and mostly clean-shaven or moustached. They wore their hair long and washed it with lime (made from limestone) to make it white. The most important people in Celtic society were military leaders and priests and priestesses, called Druids. The Celts had their own language and a rich history, which was passed down through the generations in poetry, songs and tales of heroes.

The Gunderstrup cauldron
The Gunderstrup cauldron, 42 cm high and 69 cm across, is in the National Museum of Denmark, in Copenhagen. At least three artists seem to have worked on the panels. The outer panels and the base were originally covered with thin gold foil.

THE ROMANS IN FRANCE

The Romans came to southern Gaul in 154 BC to defend the cities of Nice and Antibes against Gallic tribes. In 125 BC, Roman soldiers took control of this part of Gaul, called Provence, and in 58 BC the whole of Gaul became part of the Roman Empire under Julius Caesar. The Romans stayed in Gaul for almost 500 years.

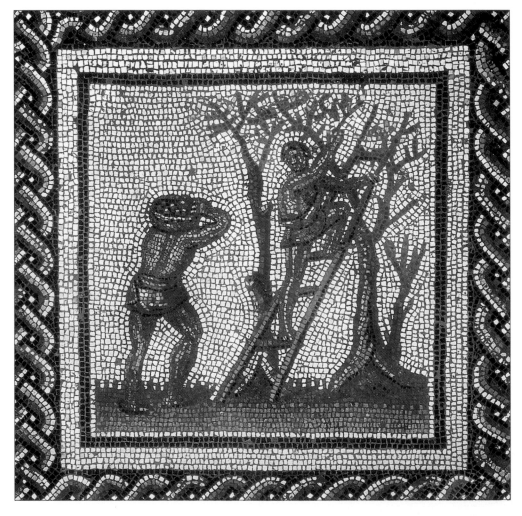

A Roman mosaic
Mosaics made from little pieces of stone or glass were a popular way of decorating the floors and walls of Roman buildings.

The Romans thought the Gauls were wild, uncivilized people who worshipped primitive gods. The Romans introduced their own gods and goddesses to the Celts, and replaced the Celtic language with Latin. Some of the Gauls were forced into slavery, others were made to join the Roman army. The Romans used their engineering skills to build a vast network of roads and bridges so that their armies could move quickly around the country and goods could be carried easily from farm to market. Huge aqueducts brought water from rivers and lakes to the growing villages and towns. Roman villas decorated with columns and porches replaced the simple Celtic huts. Beautiful wall paintings and mosaics, like the one shown here, decorated their walls and floors. The Romans built temples for religious worship and amphitheatres for games and entertainment.

Roman roads, aqueducts, temples and amphitheatres can still be seen in modern-day France. Triumphal arches, like the one shown here, have also survived. These were built to commemorate Roman victories over the local people.

While the Romans occupied Gaul, missionaries from Greece began preaching the Christian faith. Christianity spread after the Roman emperor Constantine allowed freedom of religious worship in AD 313. When the Roman empire fell in AD 455, Gaul was overrun by many different tribes including Celts from Britain, Norsemen from Scandinavia and Franks from Germany, who were the strongest tribe. Clovis, chief of the Franks, united all of Gaul under his rule and the country became known as the land of the Franks, or Francia. The Christian religion survived and was adopted by Clovis and his tribes.

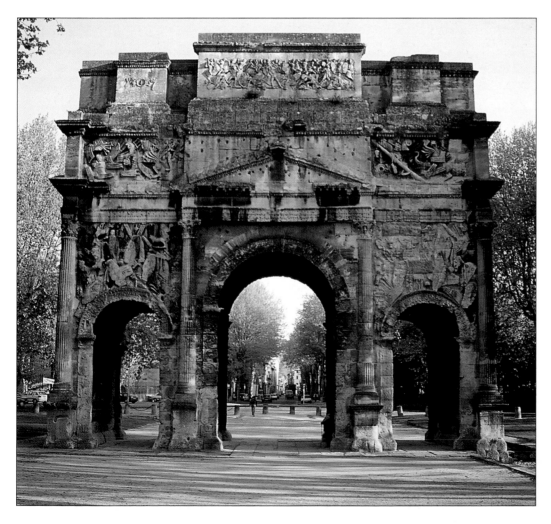

Roman arch at Orange in Provence
This triumphal arch, built around AD 21 to 26, is the third largest surviving Roman arch. It was built in honour of the Roman legion that colonized Orange in 36 BC. The carved decorations show scenes of the Romans conquering the Gauls.

CHARLEMAGNE

The Frankish empire reached the height of its power under Charlemagne (Charles the Great). King Charlemagne (AD 768–814) was a great military and religious leader. Throughout his long reign, he defended Christianity and encouraged a revival in learning and the arts.

Charlemagne fought off attacks by various tribes, such as the Saxons, Danes and Huns, and led his troops against the Muslim Arabs. Many tales of heroic deeds, or *chansons de gestes*, were written to celebrate his battles and brave deeds and those of his knights. One of the most famous of these stories is the *Chanson de Roland*, which tells of one of Charlemagne's battles against the Muslims. In AD 800, the head of the Christian Church, Pope Leo III, crowned Charlemagne emperor of western Europe.

Charlemagne was one of the first Christian kings of France, and he held his large empire together with the help of powerful bishops. He attended Mass every day and encouraged the reading of the Bible and other Christian texts, as well as the works of Greek and Roman writers. He started a revival in learning and the arts, building up the richest library in the medieval world. He invited many learned men to his court at Aachen, in present-day Germany, where he established a school. Although he had never learned to write, he learned to speak Latin and Greek and studied mathematics and astrology. Charlemagne wanted above all to help spread Christianity. He also loved family life and had at least ten children from his four marriages.

▲ The orb, or globe, is an ancient symbol of royal power all over the world. It was first used by the Roman emperors.

After his death, Charlemagne's empire was divided among his sons and then their sons. In AD 843 the Treaty of Verdun divided up the empire more or less permanently. The western part of the empire, Francia, was to become France.

Emperor Charlemagne

This bronze statue dates from the ninth to tenth century and is 24 cm high. It is in the Louvre Museum in Paris.

The Emperor Charlemagne enjoyed studying the classical literature of Greece and Rome. This portrait of him on horseback is in the style of statues of Roman emperors.

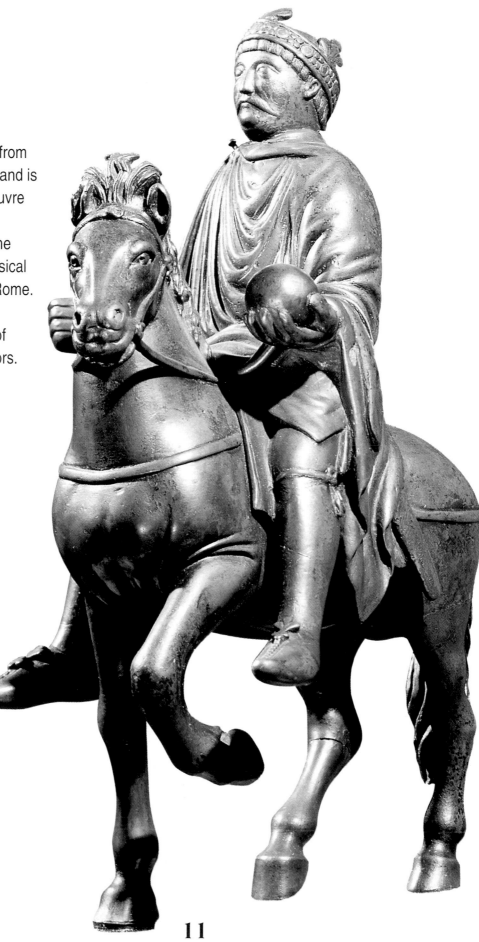

WILLIAM THE CONQUEROR

In 1066, Duke William of Normandy landed on the English coast and became William I (the Conqueror) of England. The Bayeux Tapestry tells the story of William's victory over the English king, Harold, and his Saxon army.

William, who had been made Duke of Normandy by King Henri I of France, was a fearless fighter and very clever at getting his own way. He had a claim to the English throne through his cousin Edward the Confessor, king of the Anglo-Saxons, who died without leaving a son to succeed him. William gathered together an army of knights and trained them as skilled horsemen. He supplied his men with the best war horses and the latest battle equipment.

The Bayeux Tapestry
The tapestry is at the Museum of Bayeux, in France.
This scene shows Norman knights, armed with shields and spears, riding into battle.

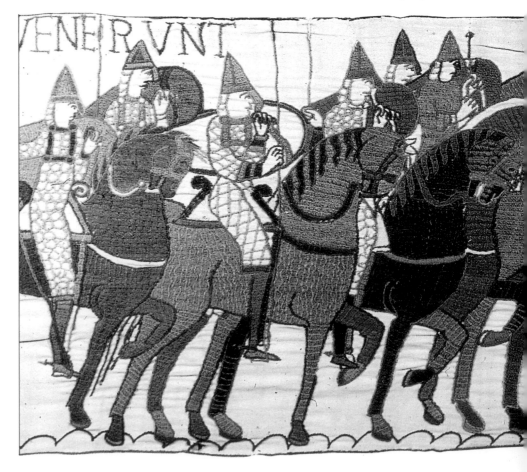

This included long swords, battle axes and stirrups, which helped the men to balance themselves when fighting on horseback. The horses were fitted with iron horseshoes to make it easier for them to travel over rough country. In 1066, William set sail from Normandy with his army and landed at Pevensey in Sussex. His army fought the battle of Hastings, beating Harold's army of Saxons, who fought on foot. William's army fought as Christian knights, under the banner of the Cross (the symbol of Christianity), with the support of the Pope.

The Bayeux Tapestry tells the story of the invasion and conquest of England by the Normans in seventy-nine different scenes. It is embroidered in woollen thread on linen panels, which altogether measure 97 m long. The tapestry was made a few years after the conquest, probably for William's half-brother Odo, Bishop of Bayeux.

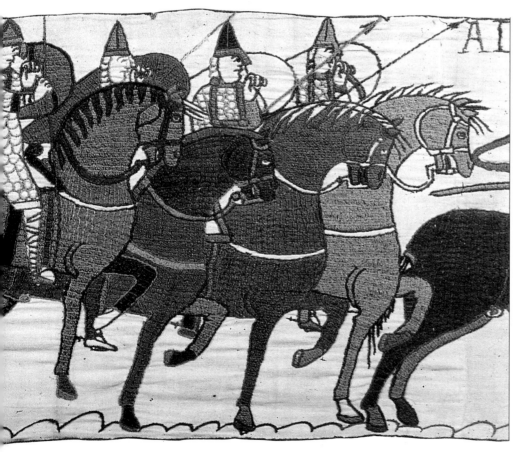

THE CRUSADES

In the Middle Ages, Christian knights became 'soldiers of Christ'. They set out on Holy Crusades to spread the Christian faith and fight against non-believers. The first Crusade set out from France in 1095.

The first Crusade set out in response to a call for help from Christians living in the city of Jerusalem. In the eleventh century, Jerusalem and much of the land known as the Holy Land (now divided among Israel, Jordan and Palestine) had come under the control of the Turks who were Muslims. Christian pilgrims could no longer travel there to see their holy places and pray. Pope Urban II received a call for help. In 1095, he gave an inspiring speech, urging all Christian knights to join together under the banner of Christ's Cross and fight to free Jerusalem. He promised forgiveness of sins and a place in heaven for everyone who joined the Crusade. While the noble families of France were preparing their knights for the journey to Jerusalem, ordinary people from the towns and countryside, inspired by the Pope's speech, set out on what became known as a 'People's Crusade'. Many people died of disease or starvation on the way; others were taken into slavery by the Turks. By 1099, however, professional soldiers had succeeded in freeing Jerusalem and restoring the city to Christianity.

By 1291 the Crusades had ended and all the land in the east was once again under the control of the Muslims. Although the Crusaders had failed to conquer the Holy Land, they learned many new things from the Muslims, who were more advanced in science and mathematics. Their knowledge was brought back to Europe by the returning Crusaders, who also brought back items such as cotton, sugar and spices, which were unknown in Europe.

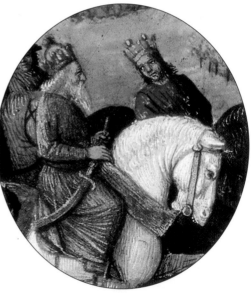

▲ Conrad III, head of the Holy Roman Empire, and King Louis VII of France – see the royal fleur-de-lys on his blue robe – joined forces to fight the Second Crusade.

The entry of Louis VII into Constantinople with Emperor Conrad III during the Crusade
from the *Chronicle of St Denis.* This is in the National Library of France, Paris

In 1147, King Louis VII of France decided to lead a second Crusade to the Holy Land. He was paying for his sins in attacking the town of Vitrey, where he had burned down a church with the congregation inside. Conrad III was Holy Roman Emperor at the time.

FARMING IN THE MIDDLE AGES

During the Middle Ages, there were important improvements in farming in France. A system of rotation of crops, leaving one field unplanted, was introduced to improve the quality of the soil. New developments in farm machinery, such as the plough, meant that more land could be cultivated.

The heavy-wheeled plough, pulled along on two wheels by oxen or horses, could dig deep furrows in the soil, turning even wet and heavy soil that could not have been worked before. The newly invented horse collar allowed farmers to use horses for ploughing; horses worked faster than oxen, although they were more expensive to buy.

This is one of the farming scenes from *Les Très Riches Heures*, a beautiful book commissioned by the Duc de Berry (1340–1416) in the fourteenth century. The Duke was the son of King John II and the brother of King Charles V. He was a great collector and patron of the arts and was especially interested in works of art and jewellery. The Duc de Berry commissioned the Limbourg brothers, who were artists, to illustrate his Book of Hours. A Book of Hours was an illustrated book containing prayers and religious texts to be read at every hour of the day. It usually included a calendar showing activities for the twelve months of the year.

This scene from *Les Très Riches Heures* illustrates the month of March. The artist has shown a farmer working a plough with oxen. The landscape is set in front of the Château de Lusignan, one of the Duke's favourite homes. To the top left is a shepherd and his dog watching a flock of sheep. Below them, three peasants are trimming vines. On the right, a man is taking seed or grain from a bag.

Les Très Riches Heures ▶
by the Limbourg brothers. It is in the Museé Condé, Chantilly.
Each month of the calendar shows seasonal tasks or pleasures and the signs of the zodiac for that time of year.

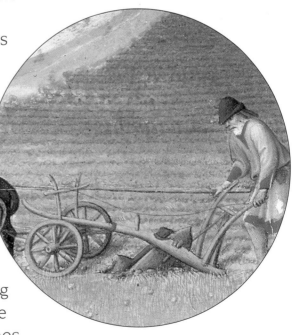

▲ The invention of the heavy-wheeled plough helped to improve medieval farming methods.

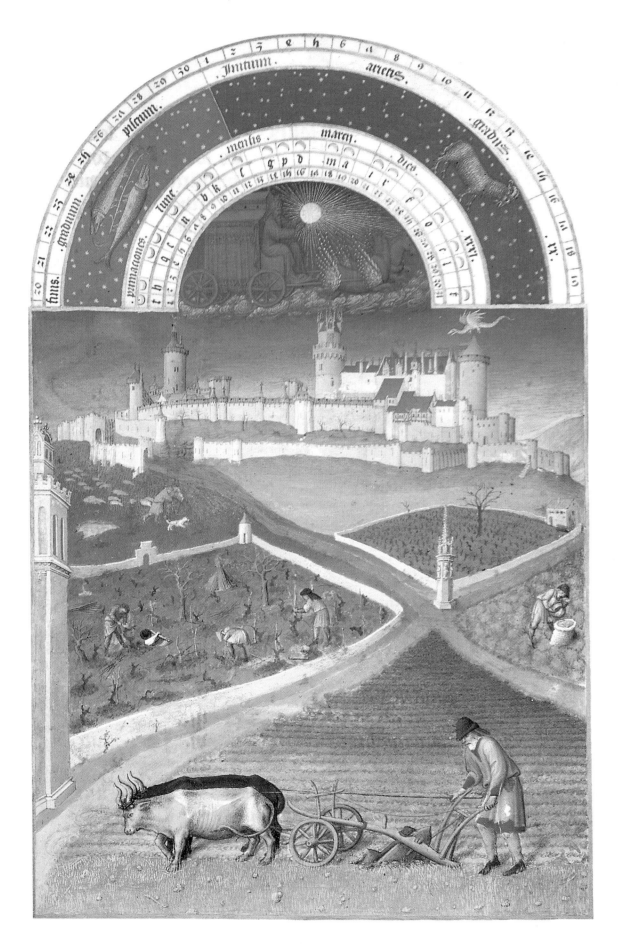

17

THE HUNDRED YEARS WAR

For over a hundred years, France was at war with England. During this long war, in which five succeeding French kings fought five succeeding English kings, a young heroine emerged to lead the French troops. Her name was Joan of Arc.

The Hundred Years War was caused by disagreements over claims by the English kings to parts of France. The war lasted from 1337 to 1453. During this time, there were periods of uneasy peace, broken by occasional fighting. The most important English victories were at Crécy in 1346 and at Agincourt in 1415. In 1422, when Charles VI of France died, the French throne was awarded to his grandson, Henry VI of England, and not to Charles, the French Dauphin (the king of France's eldest son).

The Hundred Years War from Jean Froissart's *Chronicles.* It is in the National Library of France, Paris.

This illustration is from Jean Froissart's *Chronicles*, written in the fifteenth century. It shows a scene from a battle between the French and English during the reign of King Charles V (1364–80).

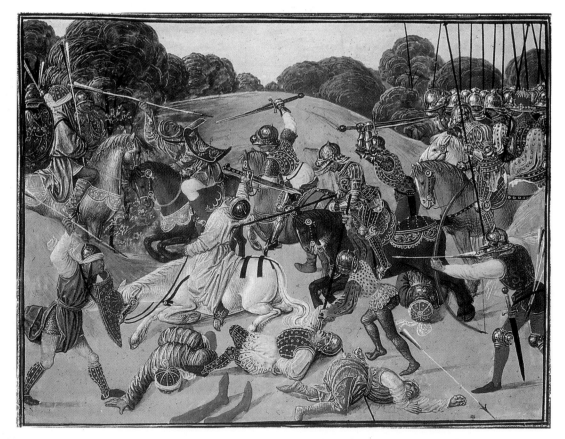

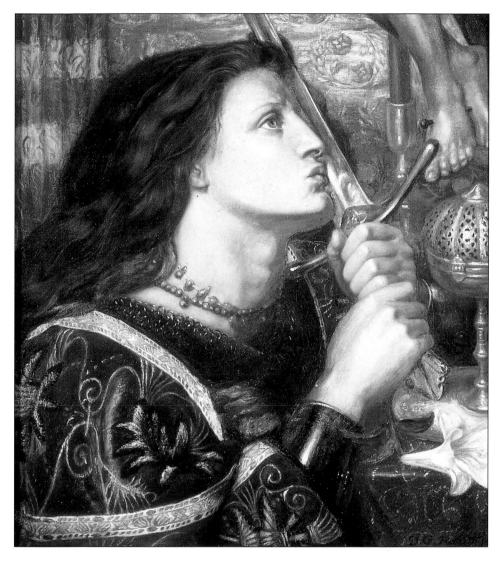

Joan of Arc Kissing the Sword of Deliverance
by Dante Gabriel Rossetti (1828–82). This painting is in a private collection.
The story of Joan of Arc has inspired artists throughout the ages. This scene, showing Joan's great religious devotion, was painted in 1863 by a British artist.

Joan of Arc helped to turn the war in France's favour. Joan was just thirteen years old when she had visions of saints who urged her to help the Dauphin Charles. She dressed herself as a boy and rode off to see the Dauphin. He allowed her to lead his troops to end the siege at Orléans. The soldiers were so impressed with her courage that they fought with great spirit, and the English fled. The Dauphin was crowned king in 1429, and the French went on to win more battles. In 1430, Joan was captured and sold to the English, who believed she was a witch. She was tried and charged with witchcraft, and on 30 May 1431 she was burned at the stake. She was just nineteen years old. Later, Joan was declared innocent, and in 1920, the Roman Catholic Church proclaimed her a saint.

By 1453, the French succeeded in driving the English out of France, except for the port of Calais, which the English held for the next hundred years. After a century of war, France emerged stronger and more united under King Charles VII.

FRANÇOIS I AND THE FRENCH RENAISSANCE

François I (1494–1547) ruled France during the great flowering of learning and the arts, called the Renaissance, that swept through Europe during the fifteenth and sixteenth centuries. François invited the best artists from Italy and France to his court, and his palace at Fontainebleau became a showcase for painting, sculpture, furniture and decoration.

King François I wanted to create a court famous for learning and the arts, so he employed the best artists and sculptors of the time and built up a vast art collection and library. He invited the great Italian painter Leonardo da Vinci to France, making him his Chief Painter, Engineer and Architect. The Bellini brothers, famous Italian artists, and the goldsmith Benvenuto Cellini came from Italy to work at the king's palace at Fontainebleau. Other Italian and French artists created the School of Fontainebleau, developing a new style of art known as Mannerism, with elegant, elongated figures. This portrait of François I on horseback is by the French artist François Clouet. Clouet was employed as Gentleman in Waiting to the king, and many of his paintings record the style, costumes and ceremonies of the court of King François I.

The questioning spirit of the Renaissance led many people to challenge the religious views of the Church and the authority of the Pope. The demands for reform within the Church by some of the clergy turned into a religious movement known as the Reformation. Protests against the Catholic Church and the drive to reform it resulted in the creation of many different branches of Protestant churches throughout northern Europe. Many French nobles became Protestants in the 1500s.

Portrait of François I on Horseback ▶
by François Clouet (1510–72). This painting is in the Galleria Degli Uffizi, Florence, Italy.

François I was a strong, intelligent leader who loved life. He was skilled at hunting, jousting and warfare, often fighting alongside his troops in the front line. The artist Clouet shows him here dressed in richly decorated armour.

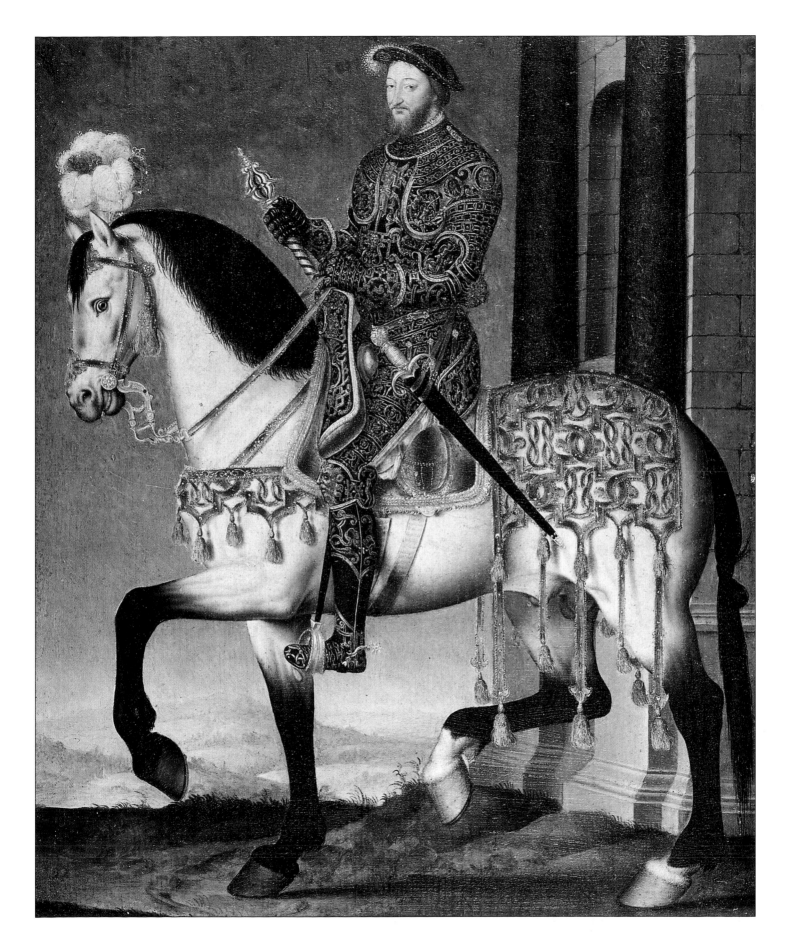

21

THE RELIGIOUS WARS

The growing conflict between Catholics and Protestants (called Huguenots), who were the followers of the French Protestant leader John Calvin, resulted in a civil war that lasted from 1562 to 1629. The war brought violence and hardship to many people. Families broke up, churches were destroyed, priests murdered and congregations massacred. One of the most terrible massacres took place on St Bartholomew's Day, 24 August 1572, when hundreds of Huguenots were killed by a Catholic mob in Paris.

The Catholic League Marching in 1593

by an unknown artist. This painting is in the City of Paris Museum.

The Catholic League included members of the nobility, who were dressed in armour, and robed priests and monks, all carrying pikes and swords.

Many who were loyal to the old religion joined together to form an organization called the Catholic League, to defend their faith. This picture shows members of the Catholic League demonstrating in Paris in 1593 to bring pressure on King Henri IV, who was a Protestant, to accept the Roman Catholic religion. The fighting ended when Henri agreed to become a Catholic. In 1598, he issued the Edict of Nantes, a royal command that gave Protestants freedom to worship in their own churches within certain towns in France and to occupy some official positions.

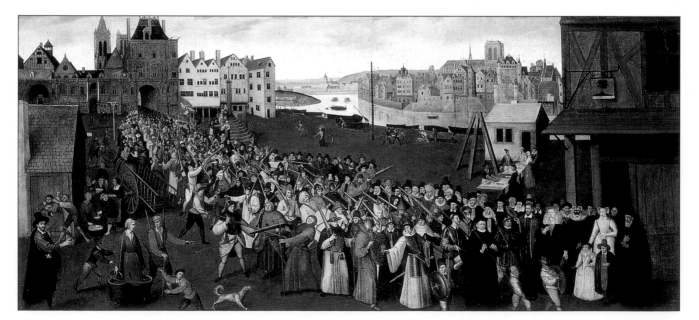

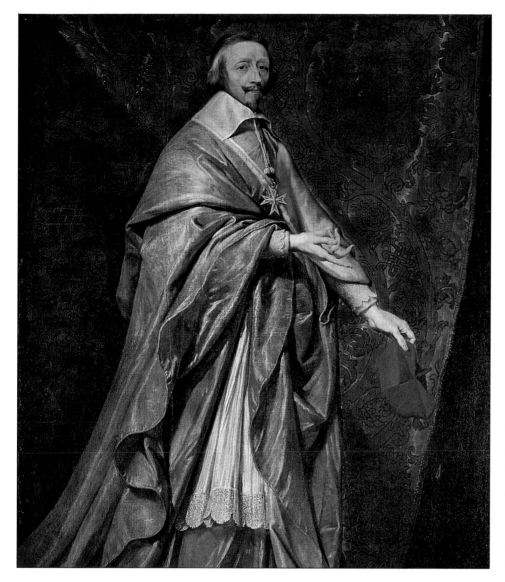

Cardinal Richelieu
(detail) by Philippe de Champaigne (1602–74). This painting is in the Louvre Museum, Paris.

Cardinal Richelieu was Louis XIII's chief minister from 1624 until his death in 1642. Richelieu dominated the French government and established strong central control. His expansion of French power overseas made France the strongest country in Europe.

Henry IV was assassinated in 1610 and his nine-year-old son became King Louis XIII. The nobles turned against King Louis, and once more there was fighting between Catholics and Huguenots. Louis' prime minister and chief advisor, Cardinal Richelieu, took steps to reduce the power of the Huguenots and strengthen the power of the king. He sent government officers all over France to bring peace to the country. He also strengthened the king's army, and sent troops to expand French power overseas and to take control of Huguenot strongholds such as La Rochelle, an important port on the west coast of France. Richelieu worked hard to strengthen the power of the king so that in future the kings of France could rule with absolute, or unlimited, power.

THE REIGN OF THE SUN KING

King Louis XIV was known as the Sun King. He ruled as an absolute monarch, which meant he had total control over France. During his long reign, France became an important power in Europe, but the extravagance of the royal court and costly wars abroad meant that the country was heading for financial ruin.

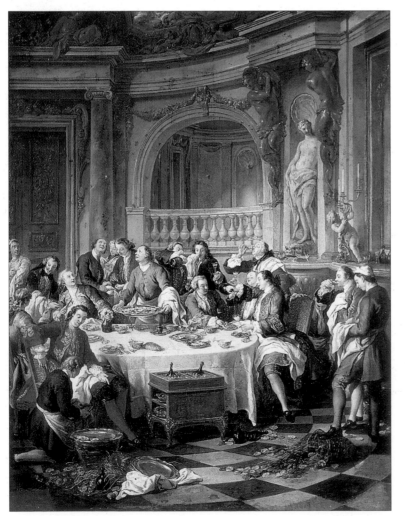

The Oyster Eaters
by Jean François de Troy (1679–1752). It is in the Musée Condé, Chantilly.

Louis became king in 1643 when he was only five years old. His reign lasted seventy-two years and was the longest in European history. Louis was a strong and powerful king. He cancelled the Edict of Nantes and tried to stamp out the Huguenots. Thousands were forced to flee from the country. He was also a great patron of the arts, inviting the finest musicians, artists and writers to the court and holding splendid parties with music, games and gambling.

Louis XIV is best remembered for the magnificent palace that he had built at Versailles, outside Paris. The front of the palace was 402 m long. Inside, were grand rooms lined with marble and full of gold-painted furniture, tapestries and art treasures. One room, the Hall of Mirrors, was lined with glass to reflect thousands of candles. The park at Versailles was laid out as a huge formal garden, with many flowerbeds, lawns, temples, statues and even a zoo. Water was pumped from the River Seine 2.5 km away to supply thousands of fountains and a canal, on which were miniature ships, gondolas and swans.

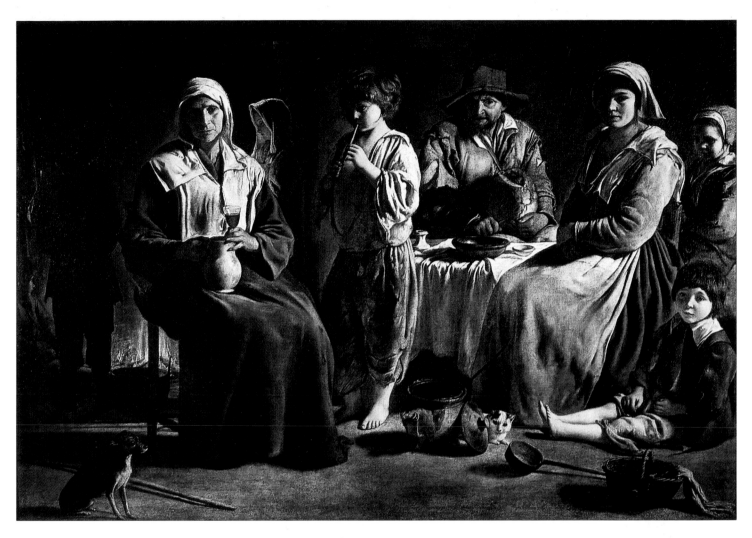

In contrast to the comforts and luxury of the royal court, life for peasants in seventeenth-century France was hard. They had to pay heavy taxes to their landowning lords and to the Church. Many families lived in great poverty, in simple houses built of wattle and daub with thatched roofs. Windows had no glass, and the furniture was very basic. Most peasants' clothes were made of coarse cloth, and they wore wooden clogs because shoe leather was expensive. Farming methods were still primitive. Crops were not plentiful, and frequent poor harvests meant that people were often short of food. Most families survived on a diet of rye bread and dripping, porridge and soup. Meat, except bacon, was rarely eaten. The highlights of the year were the saints' days, when everyone had a holiday and celebrated with games and dancing.

Peasant Family in an Interior
by Louis le Nain (1593–1648). This painting is in the Louvre Museum, Paris.

The poor clothes and bare feet of Louis le Nain's peasants as they prepare to eat a simple meal (above) are in striking contrast to the lavish costumes and the extravagant lunch of oysters and champagne enjoyed by the rich, as painted by François de Troy (opposite).

THE ENLIGHTENMENT

By the eighteenth century, scientists had shown that the universe was governed by certain natural laws. A number of philosophers and writers in France reasoned that there must be the same type of natural laws governing society, and they wanted to re-organize society on the basis of these laws. They criticized governments that gave absolute power to monarchs and allowed terrible inequalities between rich and poor. This period of new ideas is called the Enlightenment.

These ideas were spread by books and newspapers, but most importantly, through the *Encylopédie*, which was published between 1752 and 1780. This encyclopaedia of the arts and sciences was put together under the direction of Denis Diderot (1713–84), a leading philosopher. The *Encylopédie* contained articles written by some of the greatest philosophers of the day, including François Marie Arouet (1694–1778), who wrote under the name of Voltaire, and Jean-Jacques Rousseau (1712–78).

Voltaire was a rebel all his life, fighting against injustice and inequality, and was twice exiled from France for his outspoken views. While living in England he came to admire the British system of government, as well as the freedoms of speech and the press and the toleration of religions that he found there. Back in France, in 1734, he published *Philosophical Letters* praising the British system.

Rousseau believed in the basic goodness of human nature and felt that everyone should be given an equal chance in life. In his book *The Social Contract*, he argued for democracy and the freedom of the individual. These views were widely praised during the French Revolution, and they had a great influence on the writing of the American Declaration of Independence of 1776.

Voltaire Getting out of Bed ▶
by Jean Huber (1721–86).
This painting is in Ferney Castle, Vevey, Switzerland.

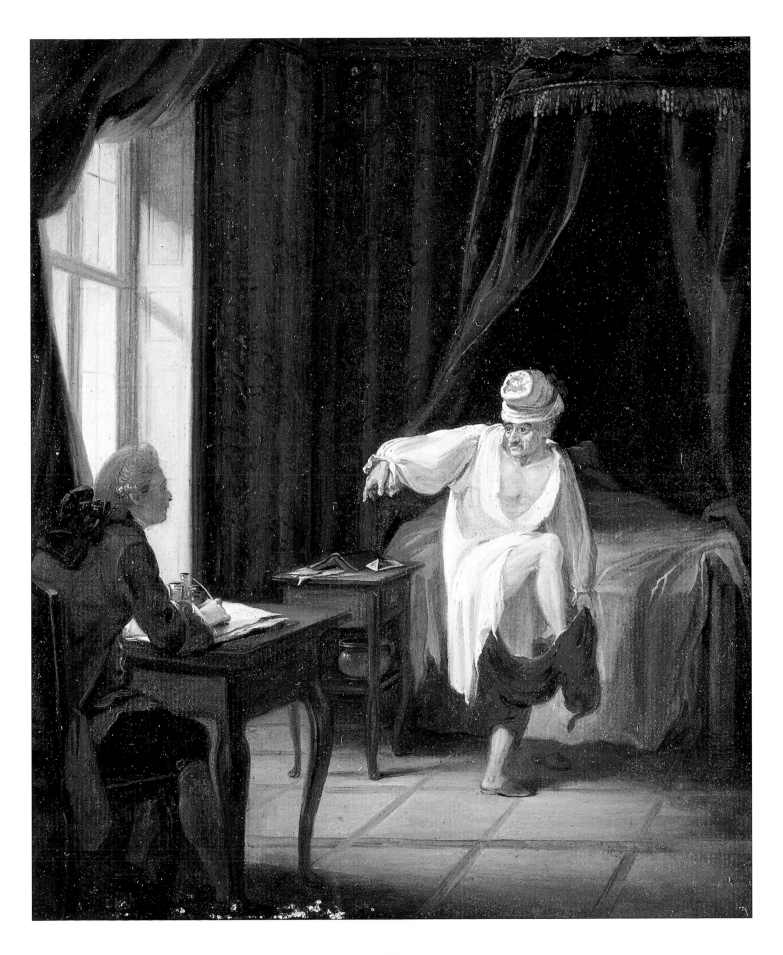

THE FRENCH REVOLUTION

**The French Revolution (1789–99) was a turning point in France's history.
The people rose up against the king, and France became a republic.**

At the outbreak of the French Revolution, society in France
was strictly ordered. The king held absolute power. The rest
of society belonged to one of three classes, or estates: the
First Estate, made up of the clergy; the Second Estate,
made up of the nobility; and the Third Estate, made up of
everyone else, including professional people, workers and
peasants. The first two estates owned most of the land,
had special privileges and paid lower taxes. The Third
Estate played no part in running the country.

The Third Estate blamed the government for high prices
and unemployment, and they resented the extravagant
spending of King Louis XVI and Queen Marie Antoinette.
Inspired by the new ideas of the Enlightenment, they
began to demand reforms. In 1789, the king called a
meeting of the Estates General, an assembly of represen-
tatives from all three estates, in order to raise taxes. The
Third Estate formed itself into the National Assembly, with
the purpose of creating a new type of government, and
forced the other two estates to join and co-operate with it.

The National Assembly began to introduce reforms. But
the people were becoming increasingly restless; prices
were going up and food was in short supply because of
poor harvests, causing widespread hunger and discontent.
On 14 July 1789, after weeks of riots and strikes, the people
of Paris attacked the Bastille prison and freed all the
prisoners. The French Revolution had begun. The
destruction of the prison excited the people, and the king
was forced to give up control of Paris. The news of the

fall of the Bastille spread to towns and cities all over France. Rioting crowds attacked town halls, forcing out royal officials and setting up their own local governments. All over the country, there were peasant uprisings and attacks on the property of rich landowners.

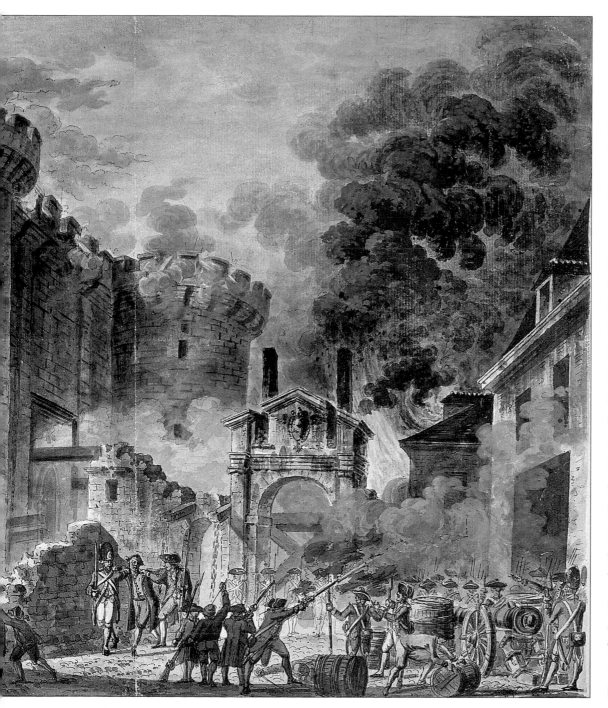

The Taking of the Bastille by Jean-Pierre Houel (1735–1813). It is in the City of Paris Museum.

The Bastille prison represented all that was hateful about the king's power. Here, his enemies were kept in chains, in dark dungeons. During the attack on the Bastille, the guards opened fire, killing about a hundred people, but the crowds stormed inside the prison, killed the guards and freed the prisoners. Today, the French people celebrate the anniversary of the fall of the Bastille, 14 July, as their independence day.

THE REIGN OF TERROR

By 1791, the Revolution was taken over by a small group of men who ordered the execution of anyone believed to be an 'enemy of the Revolution'. At first it was mainly the clergy and nobility who were sent to the guillotine – the new device for cutting off heads. Later, ordinary people were also put to death. Thousands were guillotined during the Reign of Terror.

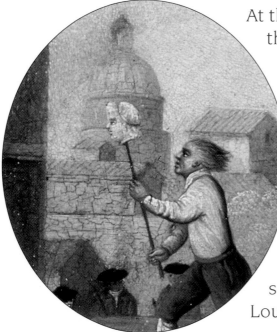

▲ Marie Antoinette's head is displayed to the crowd so that they can cheer her death.

At the beginning of the Revolution the king remained on the throne but with limited power. However, many people thought that the king was plotting with other countries to overthrow the Revolution. In 1791, the royal family tried to escape, but they were captured and imprisoned. Fear and panic now began to sweep the country. Many members of the clergy and nobility were imprisoned or murdered. The National Assembly was overthrown by extreme revolutionaries, who took control of France. 'The Reign of Terror' followed during which a committee of twelve men, headed by Maximilien Robespierre, sent thousands of people to the guillotine. In 1793, Louis XVI and Marie Antoinette were publicly guillotined.

Finally, the members of the committee, fearing that their own lives were in danger, plotted against Robespierre. In 1794, he was arrested and executed. The Reign of Terror was over. A new government, called the Directory, was established, headed by five men. By 1799, the Directory was unpopular and close to collapse. The government, surrounded by enemies, was at war with Austria, Prussia (part of present-day Germany), Britain, the Netherlands and Spain. The people wanted a strong leader to bring peace. On 9 November 1799, the Directory was overthrown by a rising young general – Napoleon Bonaparte.

The Execution of Marie Antoinette

by an unknown artist. This painting is in the Museum of the City, Paris.

In 1793, Queen Marie Antoinette was taken in a horse-drawn cart from prison to the guillotine, while the crowds jeered. Her vanity and luxurious lifestyle had made her very unpopular. She spent huge sums of money on clothes and jewellery and on the gardens of *Le Petit Trianon*, her little palace in the grounds of Versailles where she played at being a poor country wife. Those who lived in real poverty resented such extravagance.

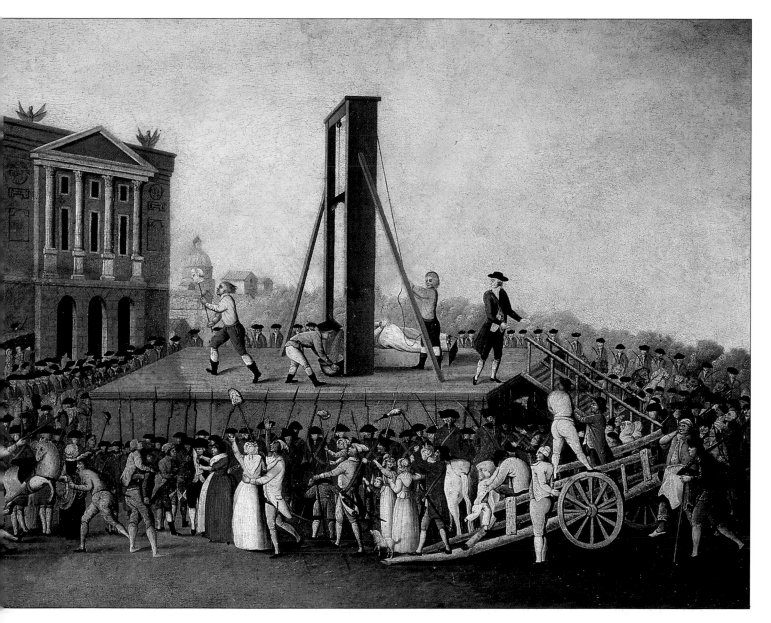

NAPOLEON BONAPARTE

Napoleon had made his name as a military leader with victories against the Austrians in Italy and against the Egyptians. In 1799, on returning from Egypt, Napoleon forced the Directory out of office and set up a government of three men, called a consulate, with himself as first consul.

As first consul, Napoleon did a great deal to reform the government. He set up the Napoleonic Code, which is still the basis of modern French law. In 1804, Napoleon was declared emperor of France. The French empire was almost always at war. By 1810, it dominated most of continental Europe. When Napoleon's armies invaded Russia in 1812, however, they were badly defeated and forced to retreat. An army of European nations, including Britain and Russia, occupied Paris in 1814. Napoleon was forced to

Coronation of Napoleon by Pope Pius VII
by Jacques Louis David (1748–1825). It is in the Louvre Museum, Paris.

During the ceremony, Napoleon took the crown from the Pope and crowned himself emperor. He then crowned Empress Josephine.

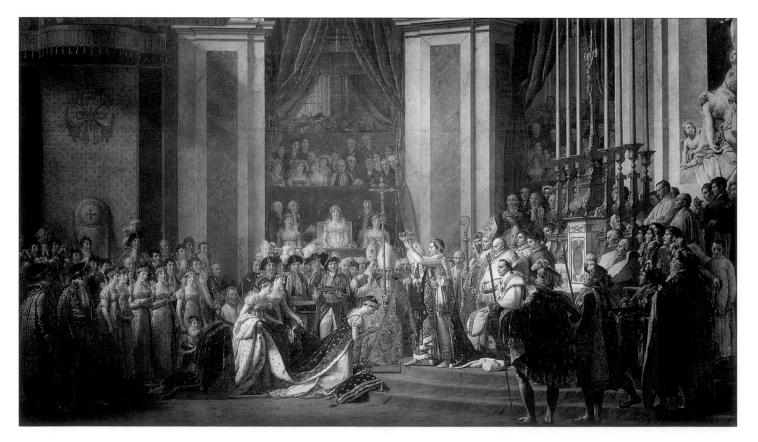

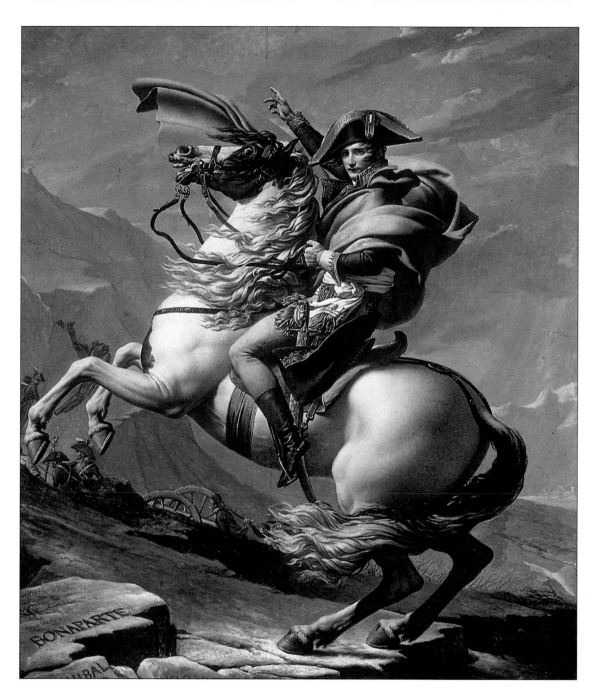

give up the throne and was sent into exile on the island of Elba, in the Mediterranean. The monarchy was restored, and Louis XVIII, a brother of Louis XVI, was made king.

In 1815, Napoleon escaped from Elba and tried to reclaim power. Supporters rallied behind him, and the king fled. Napoleon fought his last great battle at Waterloo in Belgium against the European allies led by the Duke of Wellington. Napoleon was defeated and exiled to St Helena, a remote island in the south Atlantic, where he died in 1821. Louis XVIII was put back on the throne.

Napoleon Crossing the Great St Bernard Pass
by Jacques Louis David (1748-1825). This painting is in the Historical Museum, Versailles.

Napoleon is shown as a strong, heroic leader, like Charlemagne (see page 11).

THE JULY REVOLUTION

Louis XVIII did not try to undo the reforms of the Revolution. He let the people keep the lands and the freedom they had won. But gradually, the nobility managed to regain some of the powers they had lost. There was still widespread unrest in the country; many people had no jobs and were forced to beg on the streets. In 1824, Louis XVIII's brother, Charles X, came to the throne. He was against the Revolution and sympathized with the nobility.

In July 1830, newspaper articles were printed that showed how discontented people felt with the king and his government. The newspapers advised readers not to pay their taxes as a protest. The king ordered the newspapers to be shut down, but this sparked riots on the streets of Paris. Crowds tore down signs showing the royal arms and threw stones at the royal guard. The rebellion was led by journalists, students and members of the middle class, fighting alongside the working class and the unemployed. They were all unhappy at the way the government was being run, and they wanted a new leader who would support the freedom and rights of the ordinary people.

The riots, which became known as the July Revolution, forced Charles X to give up the throne. Louis Philippe, the Duke of Orleans, was proclaimed king. He became known as the 'Citizen King' because he lived in a less grand style than former French kings. However, Louis Philippe did not support a government run by elected representatives and he became increasingly unpopular with the people. Continuing unrest among the people eventually led to his overthrow.

▲ Working people are shown alongside members of the middle class, such as the man in the top hat, as they march past the dead who have already fallen in battle.

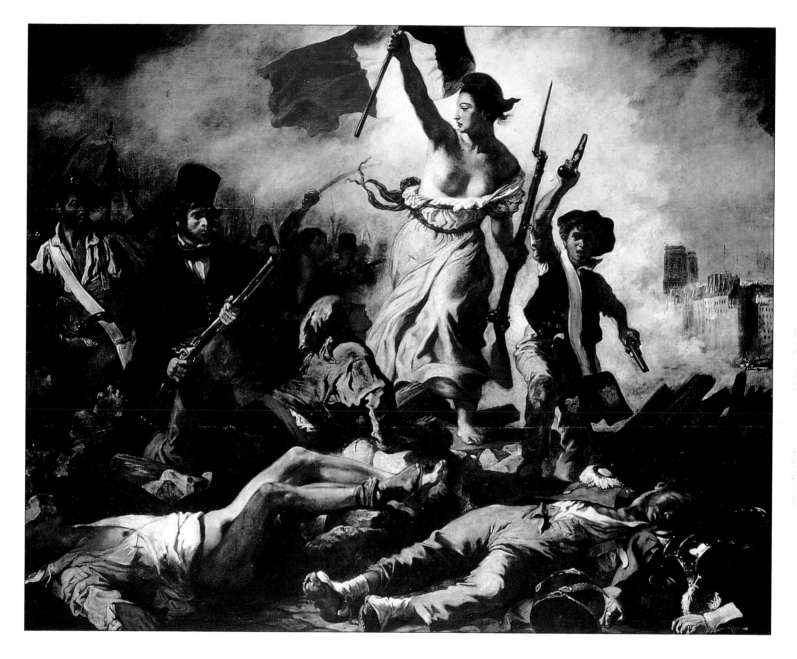

Liberty Leading the People

by Eugene Delacroix (1798-1863). This painting is in the Louvre Museum Paris.

Delacroix painted this scene from the July Revolution, with the strong, fearless
Marianne, symbol of Liberty during the Revolution, leading the people. The crowd
is about to storm through a barricade set up by the royal guard in a street in
Paris. Marianne, carrying the French flag, the Tricolour, in one hand and a gun in
the other, is inspiring the crowd on to victory.

NAPOLEON III AND THE SECOND EMPIRE

Continuing unrest among workers in Paris resulted in the overthrow of Louis Philippe's government by the Revolution of 1848. The Second Republic was declared, with Louis Napoleon Bonaparte, nephew of the former emperor, as its president. Three years later, Louis Napoleon, with the help of his strong army, declared himself emperor.

Napoleon III's rule, from 1852 to 1870, is known as the Second Empire. This was a period of wealth and stability. Paris became the centre of fashionable society, led by the Emperor Napoleon and his Spanish-born wife, Eugenie. New public buildings, roads and railways were built, and French industry grew. Paris was re-built under the direction of Baron Haussmann, who designed the impressive tree-lined avenues that can still be seen today.

Laws were passed to improve the lives of workers, allowing them the right to strike and to form unions. Napoleon III also allowed greater freedom in the press, opened new schools and improved French trade with other countries. France won victories against the Austrians in Italy, and in the Crimean War (1854–56), fighting with Britain and Turkey against the Russians. An attempt to take power in Mexico, however, resulted in a humiliating defeat.

In 1870, a dispute with Prince Otto von Bismarck, the prime minister of Prussia, provoked Napoleon III to declare war on Prussia. In this war, known as the Franco-Prussian War (1870–71), the French suffered heavy losses, and Prussian troops marched into France and besieged Paris. At the battle of Sedan (1870), Napoleon was taken prisoner and France surrendered. France was forced to give up two rich eastern provinces, Alsace and Lorraine, to the newly established German empire.

The defeat at Sedan led to revolts in Paris and other major cities. Independent local governments called communes were set up in Paris, Lyons and Marseilles. Their members (Communards) were violently opposed to the government, and they burned and ransacked public buildings and took government officials hostage. After two months of bitter fighting, government troops finally took control of the communes, rounding up and shooting the Communards. But the Second Empire had collapsed.

Empress Eugenie and her Ladies in Waiting
by Franz Xavier Winterhalter (1806–73). This painting is in the Chateau de Compiègne, France.

The Spanish-born Empress Eugenie was an elegant leader of fashion in nineteenth-century Paris.

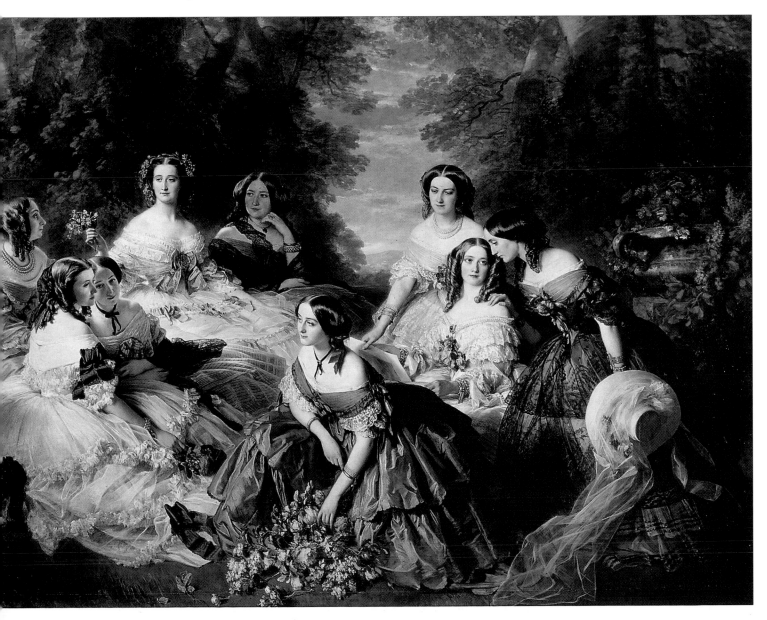

NINETEENTH CENTURY: WORK AND LEISURE

Political unrest and revolutions meant that the Industrial Revolution came late to France. In the mid-nineteenth century, most working people were farm labourers or traditional craftsmen. Towards the end of the century, trade and industry were expanding and many people moved from the countryside to the towns to find work in the new factories and shops.

There was a growing awareness of the need to improve the lives and working conditions of the poor. A series of strikes and revolts gradually led to reform. Sympathy for the poor was reflected in the art of the nineteenth century, as can be seen by this picture by Gustave Courbet. He was one of the first artists to paint in a style known as Realism. He painted scenes from everyday life rather than portraits of the rich and famous or grand themes such as battle scenes.

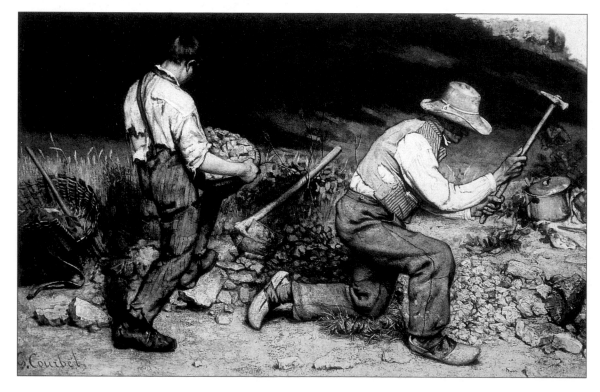

The Stone Breakers by Gustave Courbet (1819–77). The picture was in the Dresden State Museum, Germany, but was destroyed in 1945.

Many people found this painting shocking because it showed the harsh reality of the life of poor labourers.

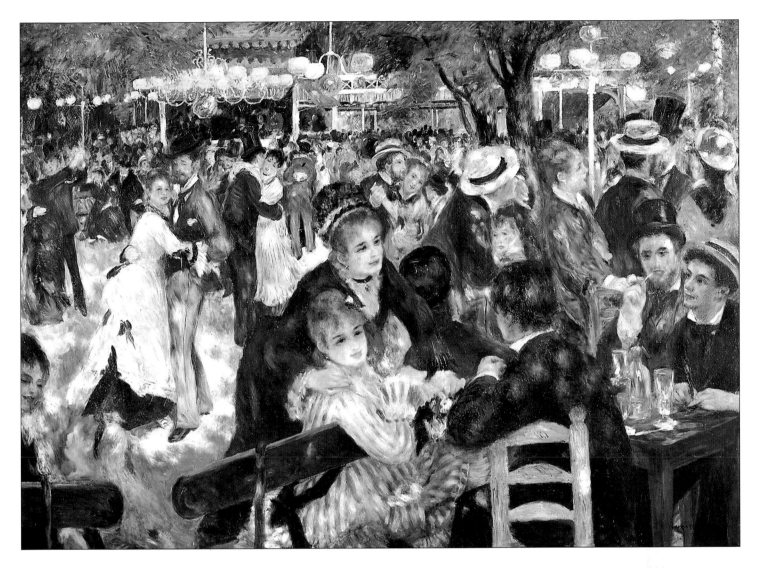

Life for the stone breakers was very different to life for young Parisians seen enjoying themselves in Renoir's *Moulin de la Galette*. Pierre Auguste Renoir was one of a group of artists known as the Impressionists, who began exhibiting in Paris in 1874. They were experimenting with new ways of painting in a lighter, brighter style, using dots and dashes of pure colour to capture the play of light. The Impressionists painted landscapes, but also the people they saw around them. They chose mainly happy, carefree scenes of people who lived and worked in Paris and had the time and the money to enjoy leisure activities. The Moulin was an outdoor dance hall where young people went to dance, drink and chat at the weekend. The people in Renoir's painting can afford to dress fashionably and go out with their friends to enjoy their leisure time.

Le Moulin de la Galette
by Auguste Renoir (1841–1919).
This painting is in the Museum of Orsay, Paris.

In contrast to Courbet's painting of the hard life of the stone breakers, Renoir's painting of an outdoor dance hall in Paris has a happy, relaxed atmosphere. The people have enough money and free time to dress smartly and to enjoy themselves at a café.

THE FIRST WORLD WAR

On 28 June 1914, a young Serbian student assassinated the Archduke Ferdinand, heir to the Austro-Hungarian empire, in the Bosnian capital of Sarajevo. His action led Austria to declare war on Serbia, which sparked off the First World War.

The causes of the war were very complex. After the Franco-Prussian War between France and Prussia, Germany was united into one country, making it the most powerful nation in Europe. Germany was worried that France would try to regain the provinces of Alsace and Lorraine, so it joined an alliance with Austria-Hungary and Italy. France, fearing the Germans, joined an alliance with Britain and Russia. The assassination in Sarajevo set old enemies against each other and brought the two European alliances to war.

In 1914, German troops marched through Belgium, which was not involved in the war, and then into northern France. They had almost reached Paris when they were turned back by intense fighting at the battle of the Marne. Both sides settled into a grim stalemate, fighting from trenches that stretched from the Swiss border to the coast of the English Channel. Hundreds of thousands of French and British soldiers died in the bloody battles of Verdun and the Somme. In 1917, the USA entered the war on the side of the French, British and Russian alliance. The following year, the allied armies finally broke through the German lines and forced them back across their borders. Germany agreed to an armistice and signed the Treaty of Versailles, which returned the provinces of Alsace and Lorraine to France. The Great War was over, but nearly 1,400,000 French people had died, and farms, factories and homes were destroyed by the fighting.

French Troops Resting, 1916 ▶
by C.R.W. Nevinson (1889–1946). This painting is in the Imperial War Museum, London.

The First World War brought a new horror: trench warfare. Soldiers fought for months from deep trenches full of mud. In advancing 'over the top', they risked slaughter by the enemy.

◄ This soldier has a large flat loaf of bread strapped to his equipment. Often the troops had to eat whenever they could, as the bombardment from the enemy continued for days at a time.

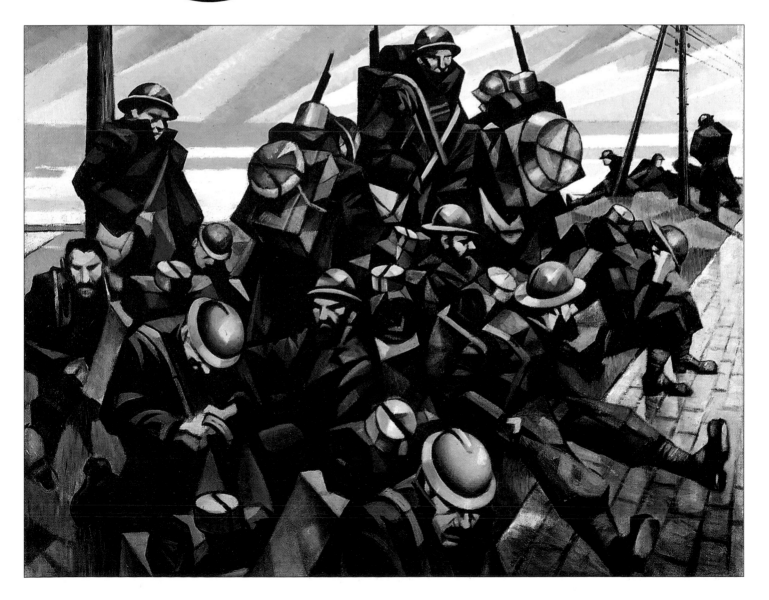

THE SECOND WORLD WAR

In the 1930s, Germany, under the Nazi leader Adolf Hitler, was making plans to expand its territory in Europe. In 1938, German troops moved into Czechoslovakia; then, a year later, into Poland. On 3 September 1939, France and Britain declared war on Germany.

In 1940, Germany invaded Denmark, Norway, the Netherlands, Luxembourg and Belgium. France was next. British troops who had been sent to help defend France became trapped at Dunkirk on the Channel coast and were rescued by boats from Britain. German forces pushed further into France. On 14 June 1940, the Germans marched into Paris.

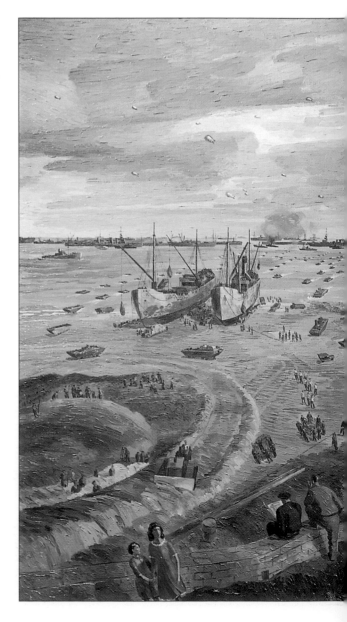

The French government signed an armistice with Germany, and France was divided into two parts – one (in the north) under direct control of the Germans and the other under a new French government, which had its capital in Vichy in central France. The Vichy government co-operated with the Germans.

Many people were opposed to both the German occupation and the Vichy government. A strong resistance movement was led by General Charles de Gaulle, who set up a government in exile in Britain and organized the Free French forces, who fought with the Allies. Members of the resistance movement within France did everything they could to help defeat the Germans. They risked their lives passing on information to the Allies, helping escaped prisoners of war and pilots who had been shot down over France and destroying communication and power lines. Many resistance fighters were killed, or captured and tortured by the Germans.

On D-Day, 6 June 1944, the Allies invaded Normandy in northern France. Free French forces and resistance workers liberated Paris as the Allies swept through northern France. General Charles de Gaulle, who led the victory parade along the Champs-Elysées in Paris, became head of the provisional government until the end of the war in 1945.

The Landing in Normandy
by Barnet Freedman (1901–58). It is in the Imperial War Museum, London.

The invasion of Normandy on D-Day was the biggest combined land, sea and air operation of all times. After heavy bombing of German coastal defences, thousands of allied forces landed on the beaches in Normandy and by nightfall had advanced several kilometres.

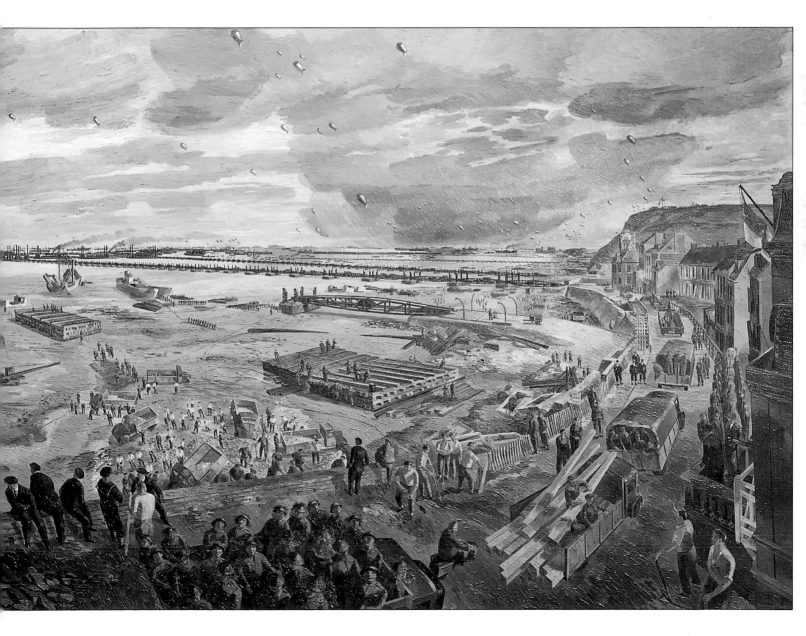

MODERN FRANCE

After the destruction of the war, the French government began to rebuild the country and modernize its shattered industries. In 1957, France helped to set up the European Economic Community and began to take on a more important role in world affairs. In 1958, a revolt in the French colony of Algeria led to its independence and the fall of the Fourth Republic. Charles de Gaulle was asked to become President of the Fifth Republic.

De Gaulle wanted to make France a strong world power. He took French forces out of NATO (the North Atlantic Treaty Organization) and developed France's own nuclear weapons. He also took steps to make French industry more successful in world markets.

In May 1968, the French government faced its biggest crisis since the Second World War. There were violent clashes between protesting students and police on the streets of Paris. The working people, already unhappy about their poor salaries and working conditions, supported the students and called a general strike. Transport was disrupted, managers were held hostage in their factories, the value of the French franc fell, and the government seemed on the verge of collapse. President de Gaulle promised reforms and a general election. His government was returned to power, but his proposals for reform were defeated and he resigned in 1969.

Modern France is one of the most powerful industrial and agricultural countries of the twentieth century. Fashion, cars, food and wine are all important exports. In the 1960s, France and Britain jointly produced the first supersonic airliner, Concorde. In 1994, the Channel Tunnel opened, providing a fast rail link between Paris and London through a tunnel under the English Channel.

The Builders ▶
by Fernand Léger (1881–1955).
This painting is in Musée National Fernand Léger, Biot, France.

After the Second World War, a major programme of modernization and rebuilding began in France. The French artist Fernand Léger painted workmen constructing a new skyscraper. The bright colours and strong, cartoon-like shapes give the picture a modern, forward-looking feeling.

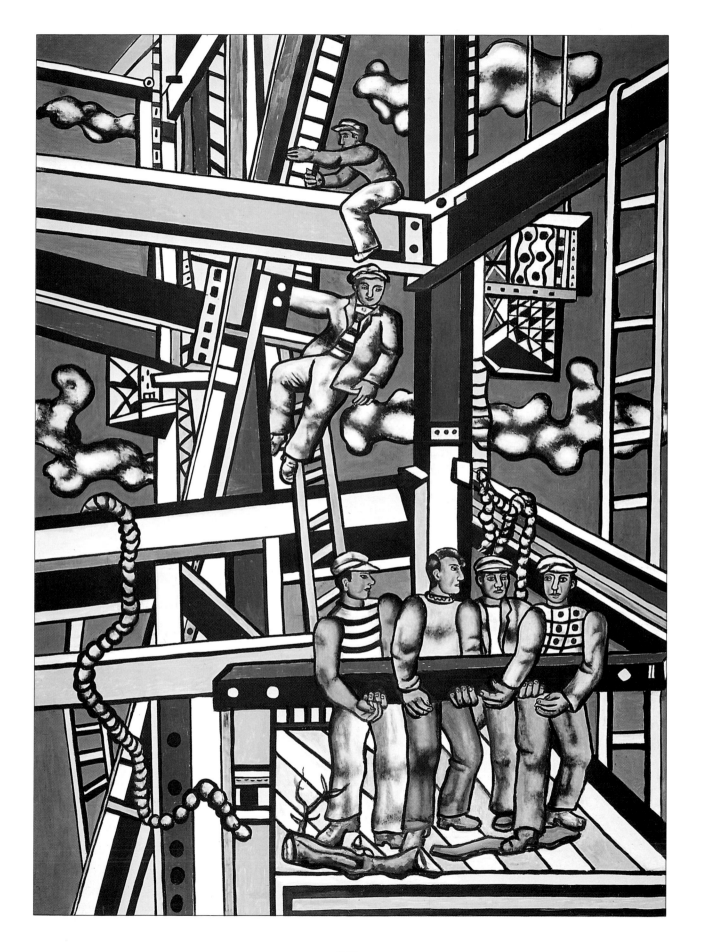

GLOSSARY

Alliance An agreement between countries to co-operate and come to each other's defence.

Allies In the Second World War, the countries fighting together to defeat Germany were known as the Allies. The main allied countries were Britain, the former USSR and the USA.

Amphitheatres Circular or oval buildings built by the Greeks and Romans, with seats rising around a central space called an arena, where entertainments took place.

Aqueducts Bridges built with channels, to take water across a valley.

Armistice A stopping of a war by agreement on all sides.

Assassinate To kill an important person.

Austria-Hungary A central European empire (1867–1918) that consisted of territories that included present-day Austria and Hungary as well as parts of several other countries.

Civil war A war between citizens of the same country.

Clergy People who are appointed by a church to perform religious duties. The clergy includes priests, nuns, ministers and bishops.

Colony A territory ruled by another country.

Court The royal household, which includes all the king's advisors and attendants.

Democracy A form of government whose members have been freely elected by the people as their representatives.

Empire A group of countries or territories under the rule of a single person, called an emperor or empress.

Exile To force a person to leave his or her own country.

Industrial Revolution The time during the eighteenth and nineteenth centuries, when European countries and the USA changed from producing mainly agricultural to mainly manufactured goods in factories.

Jousting A fight with lances between two knights on horseback.

Mass A church service performed by a priest in the Roman Catholic religion.

TIMELINE

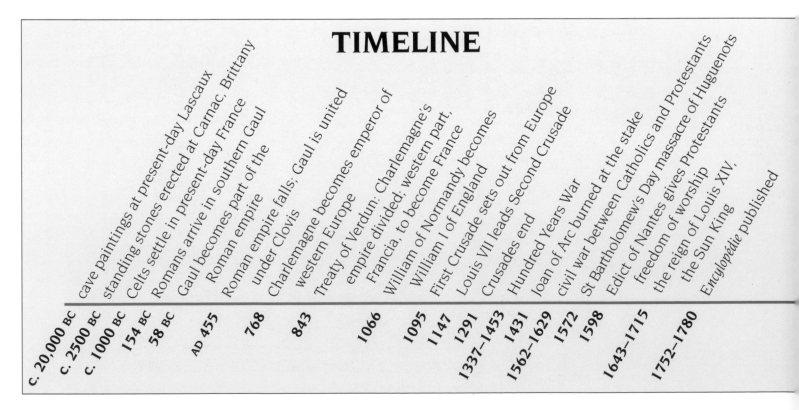

	
c. 20,000 BC	cave paintings at present-day Lascaux
c. 2500 BC	standing stones erected at Carnac, Brittany
c. 1000 BC	Celts settle in present-day France
154 BC	Romans arrive in southern Gaul
58 BC	Gaul becomes part of the Roman empire
AD 455	Roman empire falls; Gaul is united under Clovis
768	Charlemagne becomes emperor of western Europe
843	Treaty of Verdun: Charlemagne's empire divided: western part, Francia, to become France
1066	William of Normandy becomes William I of England
1095	First Crusade sets out from Europe
1147	Louis VII leads Second Crusade
1291	Crusades end
1337–1453	Hundred Years War
1431	Joan of Arc burned at the stake
1562–1629	civil war between Catholics and Protestants
1572	St Bartholomew's Day massacre of Huguenots
1598	Edict of Nantes gives Protestants freedom of worship
1643–1715	the reign of Louis XIV, the Sun King
1752–1780	Encyclopédie published

Medieval Referring to the Middle Ages.

Middle Ages The period in European history between the fifth and fifteenth centuries AD.

Missionaries People sent to another country by their Church to try to make the people there accept the beliefs of that Church.

Muslim A follower of the religion of Islam.

Nobility People who belong to a high class or rank in society.

Patron A person who sponsors or supports someone to produce a work of art.

Pilgrim A person who travels to a holy place as a religious act.

Protestant A member of one of the Christian churches that formed as a result of the Reformation.

Republic A nation in which the people are represented in government through elected representatives. The head of the state is an elected president, not a king or emperor.

Roman Catholic Church The Christian Church headed by the Pope in Rome.

Tapestry Heavy cloth woven with designs and pictures and used as a wall hanging.

Wattle and daub Walls made by weaving soft branches together and covering them with clay.

BOOKS TO READ

The Age of Revolution by Josh Brooman (Longman, 1992)

Art in the Nineteenth Century by Jillian Powell (Wayland, 1994)

The French Revolution and Napoleon by Stephen Pratt (Wayland, 1995)

Western Art: 1600-1800 by Christoper McHugh (Wayland, 1994)

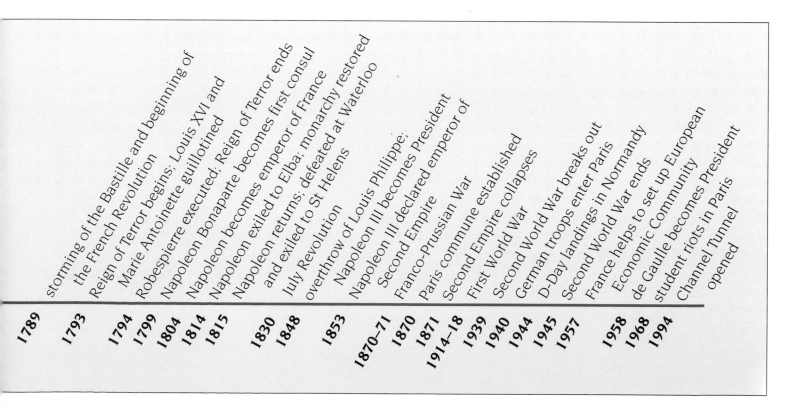

storming of the Bastille and beginning of the French Revolution — 1789

Reign of Terror begins; Louis XVI and Marie Antoinette guillotined — 1793

Robespierre executed; Reign of Terror ends — 1794

Napoleon Bonaparte becomes first consul — 1799

Napoleon becomes emperor of France — 1804

Napoleon exiled to Elba; monarchy restored — 1814

Napoleon returns; defeated at Waterloo and exiled to St Helens — 1815

July Revolution — 1830

overthrow of Louis Philippe; Napoleon III becomes President — 1848

Napoleon III declared emperor of Second Empire — 1853

Franco-Prussian War — 1870-71

Paris commune established — 1870

Second Empire collapses — 1871

First World War — 1914-18

Second World War breaks out — 1939

German troops enter Paris — 1940

D-Day landings in Normandy — 1944

Second World War ends — 1945

France helps to set up European Economic Community — 1957

de Gaulle becomes President — 1958

student riots in Paris — 1968

Channel Tunnel opened — 1994

INDEX